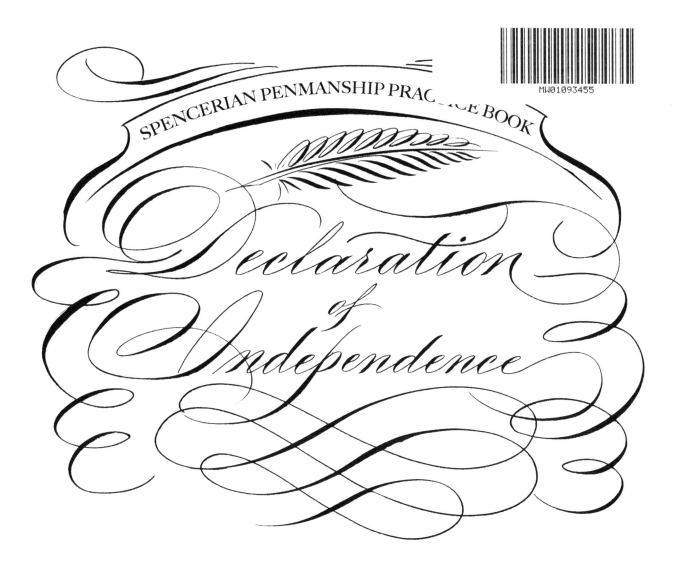

SPENCERIAN PENMANSHIP PRACTICE BOOK

Declaration of Independence

Schin Loong

Ulysses Press

Published in the United States by:
Ulysses Press
P.O. Box 3440
Berkeley, CA 94703
www.ulyssespress.com

ISBN: 978-1-61243-793-4
Library of Congress Control Number 2018930763

Printed in the United States by Kingery Printing Company
10 9 8 7 6 5 4 3 2 1

Acquisitions: Casie Vogel
Managing editor: Claire Chun
Proofreader: Claire Sielaff
Front cover design: Schin Loong
Back cover art: parchment © Color Symphony/shutterstock.com; starburst © Anna Golant/shutterstock.com
Page 6: Declaration of Independence courtesy of the National Archives

Distributed by Publishers Group West

Introduction

This book is designed to make it as easy as possible for you to practice Spencerian penmanship. Across the top of each page are the words for you to practice, and below are lines, with rules and slant guides, where you can write each word again and again. You can even tear out the perforated pages to practice on a perfectly flat surface.

While the aim of this book is to improve your Spencerian script, the practice words within are not random—they are the immortal and inspiring words that Thomas Jefferson penned in The Declaration of Independence. The entire text of the Declaration can be found on the following four pages; however, in order to reduce repetition of practice words and manage the length of this book, parts of the text were not reproduced in the practice section of this book. Those parts have been underlined on the following pages.

IN CONGRESS, July 4, 1776. The unanimous Declaration of the thirteen united States of America, When in the Course of human events, it becomes necessary for one people to dissolve the political bands which have connected them with another, and to assume among the powers of the earth, the separate and equal station to which the Laws of Nature and of Nature's God entitle them, a decent respect to the opinions of mankind requires that they should declare the causes which impel them to the separation. We hold these truths to be self-evident, that all men are created equal, that they are endowed by their Creator with certain unalienable Rights, that among these are Life, Liberty and the pursuit of Happiness. That to secure these rights, Governments are instituted among Men, deriving their just powers from the consent of the governed, That whenever any Form of Government becomes destructive of these ends, it is the Right of the People to alter or to abolish it, and to institute new Government, laying its foundation on such principles and organizing its powers in such form, as to them shall seem most likely to effect their Safety and Happiness. Prudence, indeed, will dictate that Governments long established should not be changed for light and transient causes; and accordingly all experience hath shewn, that mankind are more disposed to suffer, while evils are sufferable, than to right themselves by abolishing the forms to which they are accustomed. But when a long train of abuses and usurpations, pursuing invariably the same Object evinces a design to reduce them under absolute Despotism, it is their right, it is their duty, to throw off such Government, and to provide new Guards for their future security.—Such has been the patient sufferance of these Colonies; and such is now the necessity which constrains them to alter their former Systems of Government. The history of the present King of Great Britain is a history of repeated injuries and usurpations, all having in direct object the establishment of an absolute Tyranny over these States. To prove this, let Facts be submitted to a candid world. He has refused his Assent to Laws, the most wholesome and necessary for the public good. He has forbidden his Governors to pass Laws of immediate and pressing

importance, unless suspended in their operation till his Assent should be obtained; and when so suspended, he has utterly neglected to attend to them. He has refused to pass other Laws for the accommodation of large districts of people, unless those people would relinquish the right of Representation in the Legislature, a right inestimable to them and formidable to tyrants only. He has called together legislative bodies at places unusual, uncomfortable, and distant from the depository of their public Records, for the sole purpose of fatiguing them into compliance with his measures. He has dissolved Representative Houses repeatedly, for opposing with manly firmness his invasions on the rights of the people. He has refused for a long time, after such dissolutions, to cause others to be elected; whereby the Legislative powers, incapable of Annihilation, have returned to the People at large for their exercise; the State remaining in the mean time exposed to all the dangers of invasion from without, and convulsions within. He has endeavoured to prevent the population of these States; for that purpose obstructing the Laws for Naturalization of Foreigners; refusing to pass others to encourage their migrations hither, and raising the conditions of new Appropriations of Lands. He has obstructed the Administration of Justice, by refusing his Assent to Laws for establishing Judiciary powers. He has made Judges dependent on his Will alone, for the tenure of their offices, and the amount and payment of their salaries. He has erected a multitude of New Offices, and sent hither swarms of Officers to harrass our people, and eat out their substance. He has kept among us, in times of peace, Standing Armies without the Consent of our legislatures. He has affected to render the Military independent of and superior to the Civil power. He has combined with others to subject us to a jurisdiction foreign to our constitution, and unacknowledged by our laws; giving his Assent to their Acts of pretended Legislation: For Quartering large bodies of armed troops among us: For protecting them, by a mock Trial, from punishment for any Murders which they should commit on the Inhabitants of these States: For cutting off our Trade with all parts of the world: For imposing Taxes on us without our

Consent: For depriving us in many cases, of the benefits of Trial by Jury: For transporting us beyond Seas to be tried for pretended offences For abolishing the free System of English Laws in a neighbouring Province, establishing therein an Arbitrary government, and enlarging its Boundaries so as to render it at once an example and fit instrument for introducing the same absolute rule into these Colonies: For taking away our Charters, abolishing our most valuable Laws, and altering fundamentally the Forms of our Governments: For suspending our own Legislatures, and declaring themselves invested with power to legislate for us in all cases whatsoever. He has abdicated Government here, by declaring us out of his Protection and waging War against us. He has plundered our seas, ravaged our Coasts, burnt our towns, and destroyed the lives of our people. He is at this time transporting large Armies of foreign Mercenaries to compleat the works of death, desolation and tyranny, already begun with circumstances of Cruelty & perfidy scarcely paralleled in the most barbarous ages, and totally unworthy the Head of a civilized nation. He has constrained our fellow Citizens taken Captive on the high Seas to bear Arms against their Country, to become the executioners of their friends and Brethren, or to fall themselves by their Hands. He has excited domestic insurrections amongst us, and has endeavoured to bring on the inhabitants of our frontiers, the merciless Indian Savages, whose known rule of warfare, is an undistinguished destruction of all ages, sexes and conditions. In every stage of these Oppressions We have Petitioned for Redress in the most humble terms: Our repeated Petitions have been answered only by repeated injury. A Prince whose character is thus marked by every act which may define a Tyrant, is unfit to be the ruler of a free people. Nor have We been wanting in attentions to our Brittish brethren. We have warned them from time to time of attempts by their legislature to extend an unwarrantable jurisdiction over us. We have reminded them of the circumstances of our emigration and settlement here. We have appealed to their native justice and magnanimity, and we have conjured them by the ties of our common kindred to disavow these usurpations,

which, would inevitably interrupt our connections and correspondence. They too have been deaf to the voice of justice and of consanguinity. We must, therefore, acquiesce in the necessity, which denounces our Separation, and hold them, as we hold the rest of mankind, Enemies in War, in Peace Friends. We, therefore, the Representatives of the united States of America, in General Congress, Assembled, appealing to the Supreme Judge of the world for the rectitude of our intentions, do, in the Name, and by Authority of the good People of these Colonies, solemnly publish and declare, That these United Colonies are, and of Right ought to be Free and Independent States; that they are Absolved from all Allegiance to the British Crown, and that all political connection between them and the State of Great Britain, is and ought to be totally dissolved; and that as Free and Independent States, they have full Power to levy War, conclude Peace, contract Alliances, establish Commerce, and to do all other Acts and Things which Independent States may of right do. And for the support of this Declaration, with a firm reliance on the protection of divine Providence, we mutually pledge to each other our Lives, our Fortunes and our sacred Honor.

IN CONGRESS, JULY 4, 1776.

The unanimous Declaration of the thirteen united States of America.

Practice Section

In Congress July 4,

In Congress July 4,

1776. The unanimous

1776. The unanimous

Declaration of the

Declaration of the

thirteen united States

thirteen united States

of America, When in the

of America When in the

Course of human events, it

Course of human events, it

becomes necessary for one

becomes necessary for one

people to dissolve the

people to dissolve the

political bands which

political bands which

have connected them with

have connected them with

another, and to assume

another, and to assume

among the powers of

among the powers of

the earth, the

the earth, the

separate and equal

separate and equal

station to which the

station to which the

Laws of Nature and of

Laws of Nature and of

Nature's God entitle

Nature's God entitle

them, a decent respect

them, a decent respect

to the opinions of

to the opinions of

mankind requires that

mankind requires that

they should declare

they should declare

the causes which impel

the causes which impel

them to the

them to the

separation. We hold

separation. We hold

these truths to be

these truths to be

self-evident, that all

self-evident, that all

men are created equal,

men are created equal,

that they are endowed

that they are endowed

by their Creator with

by their Creator with

certain unalienable Rights,

certain unalienable Rights,

that among these are

that among these are

Life, Liberty and the

Life, Liberty and the

pursuit of Happiness. That

pursuit of Happiness. That

to secure these rights,

to secure these rights,

Governments are instituted

Governments are instituted

among Men, deriving their

among Men, deriving their

just powers from the

just powers from the

consent of the governed,

consent of the governed,

That whenever any Form

That whenever any Form

of Government becomes

of Government becomes

destructive of these ends,

destructive of these ends,

it is the Right of

it is the Right of

the People to alter or

the People to alter or

to abolish it, and to

to abolish it, and to

institute new Government,

institute new Government,

laying its foundation on

laying its foundation on

such form, as to them

such form, as to them

shall seem most likely

shall seem most likely

to effect their Safety

to effect their Safety

and Happiness. Prudence,

and Happiness. Prudence,

indeed, will dictate that

indeed, will dictate that

Governments long established

Governments long established

should not be changed

should not be changed

for light and transient

for light and transient

causes; and accordingly all

causes; and accordingly all

experience hath shewn,

experience hath shewn,

evils are sufferable, than

evils are sufferable, than

to right themselves by

to right themselves by

abolishing the forms to

abolishing the forms to

which they are accustomed.

which they are accustomed.

But when a long train

But when a long train

of abuses and usurpations,

of abuses and usurpations,

pursuing invariably the

pursuing invariably the

same Object evinces a

same Object evinces a

design to reduce them

design to reduce them

under absolute Despotism,

under absolute Despotism,

such Government, and to

such Government, and to

provide new Guards for

provide new Guards for

their future Security.

their future Security.

fuch has been the

fuch has been the

patient sufferance of these

patient sufferance of these

Colonies; and such is

Colonies; and such is

now the necessity which

now the necessity which

constrains them to alter

constrains them to alter

their former Systems of

their former Systems of

Government. The history

Government. The history

repeated injuries and

repeated injuries and

usurpations, all having

usurpations, all having

in direct object the

in direct object the

establishment of an absolute

establishment of an absolute

Tyranny over these

Tyranny over these

States. To prove this,

States. To prove this,

let Facts be submitted

let Facts be submitted

to a candid world.

to a candid world.

He has refused his

He has refused his

Assent to Laws,

Assent to Laws,

He has dissolved

He has dissolved

Spencerian Penmanship Practice Book

Representative Houses,

Representative Houses,

He has endeavoured to

He has endeavoured to

prevent the population of

prevent the population of

these States; refusing to

these States; refusing to

pass others to encourage

pass others to encourage

their migrations hither,

their migrations hither,

He has affected to

He has affected to

render the Military

render the Military

independent of and

independent of and

superior to the Civil

superior to the Civil

power. He has combined

power. He has combined

with others to subject

with others to subject

us to a jurisdiction

us to a jurisdiction

foreign to our constitution,

foreign to our constitution,

and unacknowledged by

and unacknowledged by

our laws; giving his

our laws; giving his

Assent to their Acts

Assent to their Acts

of pretended Legislation:

of pretended Legislation

For Quartering large

For Quartering large

bodies of armed troops

bodies of armed troops

among us: For cutting

among us: For cutting

off our Trade with all

off our Trade with all

parts of the world:

parts of the world

For depriving us in

For depriving us in

many cases, of the

many cases, of the

benefits of Trial by

benefits of Trial by

Jury: He has excited

Jury: He has excited

domestic insurrections

domestic insurrections

amongst us. In every

amongst us. In every

stage of these Oppressions.

stage of these Oppressions.

We have Petitioned for

We have Petitioned for

Redress in the most

Redress in the most

humble terms: Our

humble terms Our

repeated injury. A

repeated injury. A

Prince whose character

Prince whose character

is thus marked by

is thus marked by

every act which may

every act which may

define a Tyrant, is

define a Tyrant, is

unfit to be the

unfit to be the

ruler of a free people

ruler of a free people

We, therefore, the

We, therefore, the

Representatives of the

Representatives of the

united States of

united States of

America, in General

America, in General

Congress, Assembled,

Congress, Assembled,

appealing to the

appealing to the

Supreme Judge of the

Supreme Judge of the

world for the rectitude

world for the rectitude

of our intentions, do, in

of our intentions, do, in

the Name, and by

the Name, and by

Authority of the good

Authority of the good

People of these Colonies,

People of these Colonies,

Solemnly publish and

Solemnly publish and

declare, That these

declare, That these

United Colonies are, and

United Colonies are, and

of Right ought to be

of Right ought to be

Free and Independent

Free and Independent

States; that they are

States; that they are

Absolved from all

Absolved from all

Allegiance to the

Allegiance to the

British Crown, and that

British Crown, and that

all political connection

all political connection

between them and the

between them and the

State of Great Britian,

State of Great Britian,

is and ought to be

is and ought to be

totally dissolved; and that

totally dissolved; and that

as free and Independent

as free and Independent

States, they have full

States, they have full

Power to levy War,

Power to levy War,

conclude Peace, contract

conclude Peace, contract

Alliances, establish

Alliances, establish

Commerce, and to do all

Commerce, and to do all

other Acts and Things

other Acts and Things

which Independent

which Independent

States may of right do.

States may of right do.

And for the support of

And for the support of

this Declaration, with

this Declaration, with

a firm reliance on the

a firm reliance on the

protection of divine

protection of divine

Providence, we mutually

Providence, we mutually

pledge to each other our

pledge to each other our

Lives, our Fortunes and

Lives, our Fortunes and

our Sacred Honor.

our Sacred Honor.

About the Calligrapher

Schin Loong is a calligrapher and artist. She is a member of IAMPETH (The International Association of Master Penmen, Engrossers and Teachers of Handwriting) and has studied under various Master Penmen, including Michael Sull, America's foremost Spencerian penman.

She lives in Las Vegas, Nevada.